oems revels in what is left unsaid, what is erased ... tion, and what is uncovered only through restraint. Tomkinson discovers a new diction, hidden in the dictionary.
　　—Derek Beaulieu, Banff Poet Laureate, author of *Surface Tension*

A work of linguistic delight and density. Tomkinson has created a book of wonders, if you like words.
　　—SJ Fowler, author of *The Great Apes*

Cling to the masts of meaning, or give way to the sirens, plunge into the sawtoothed music, and find joy in the tantalizing elusiveness of Tomkinson's *oems*.
　　—Jessica Sequeira, author of *A Luminous History of the Palm*

This book explores the sweaty dance of anxious words. It lures in logophiles (like me) with arenaceous ear worms. Linger, then, on each word. Savour each careworn ligature.
　　—Gregory Betts, author of *Foundry*

How delightful to find in these lipograms not only a winning sense of humour but warm blood coursing from lungs to heart to groin.
　　—Jake Byrne, author of *Celebrate Pride with Lockheed Martin*

Tomkinson wanders the gently rolling landscapes of a 14-letter alphabet, creating an alluring collection—a curious, noun-woven reverie.
　　—Luke Bradford, author of *Zoolalia*

Painting himself into a corner with language, singing from the cell of the prisoner's constraint, Tomkinson sonorously navigates the limits of his oems. This is a book that will draw you in—and not let you go.
　　—Sacha Archer, author of *Mother's Milk*

oems

ESSENTIAL POETS SERIES 299

 Canada Council **Conseil des Arts**
for the Arts **du Canada**

 ONTARIO ARTS COUNCIL
CONSEIL DES ARTS DE L'ONTARIO

Guernica Editions Inc. acknowledges the support of the Canada Council
for the Arts and the Ontario Arts Council. The Ontario Arts Council
is an agency of the Government of Ontario.

We acknowledge the financial support of the Government of Canada.

oems

ma ew om inson

GUERNICA
EDITIONS

TORONTO – CHICAGO – BUFFALO – LANCASTER (U.K.)

2022

Guernica Founder: Antonio D'Alfonso

Michael Mirolla, editor
Cover and Interior Design: Errol F. Richardson
Guernica Editions Inc.
287 Templemead Drive, Hamilton (ON), Canada L8W 2W4
2250 Military Road, Tonawanda, N.Y. 14150-6000 U.S.A.
www.guernicaeditions.com

Distributors:
Independent Publishers Group (IPG)
600 North Pulaski Road, Chicago IL 60624
University of Toronto Press Distribution (UTP)
5201 Dufferin Street, Toronto (ON), Canada M3H 5T8
Gazelle Book Services
White Cross Mills, High Town, Lancaster LA1 4XS U.K.

First edition.
Printed in Canada.

Legal Deposit – Third Quarter
Library of Congress Catalog Card Number: 2022931159
Library and Archives Canada Cataloguing in Publication
Title: Oems / Ma[tth]ew [T]om[k]inson.
Names: Tomkinson, Matthew, 1989- author.
Series: Essential poets ; 299.
Description: Series statement: Essential poets ; 299 | Poems. | On source of infor-
mation, letters with ascenders and descenders in the statement of responsibility are
replaced with a blank space.
Identifiers: Canadiana 20220151245 | ISBN 9781771837637 (softcover)
Classification: LCC PS8639.O456 O36 2022 | DDC C811/.6—dc23

"Attend to your Configuration."
—Edwin A. Abbott, *Flatland: A Romance of Many Dimensions*

i.

an excisor – a remover
a voracious eraser
a manicure – a circumcision

mini-scourer
masonic-reasoner
noun-scanner

non-ironic verse
concise economic rime
scazon scansion

comic sans
univers
courier new

ravines run across us
simooms crisscross us
seas overcome us – uncrown us

a sensuous monomania
a riemannian essence
semi-coarse remains

as a wave curves
as a voice carves
we converse

even – uneven
uneven – even
even – uneven

ii.

concave vs. convex
maximum vs. minimum
one micron across

venus mown-over
unanimous – no variance
aeonian earworms

a scrivener resizes
ones – zeros
in mercurous merisms

cursor across screen
we move in morse
as in ascii

moiré waves
nacreous waves
mesmeric waves

scour us
caress us
uncover us

icarus waxes
ixion wanes
ascension – non-ascension

raise no crosses
no scarecrows
no american roses

iii.

an osseous snowman
a niveous mass
no corners

unseen runes
on an azonic screen
noninvasive rasure

acerous or unicornic
arm or arc
means more

semiosis is minor
a miner reveres
raw ore

unwarm
wan
anemic

a sonorousness
a ceremoniousness
a narrowness

unisonance – unicase
one noise – one mien
a monosemous excursion

no rise
in our cursive
no verruca scars

iv.

wearisome sameness
rococo run-ons
sinuous acro

susurrous arias
warm mezzos
vers anciens

noxious vim
semicomas
non-ionic verse

anosmic cuisiniers
overserious comics
xeric oceans

rosicrucianism
monas cosmos
moon – sun

inane nonsense
misocainean muses
numinous séances

acme severance
sérac recision
we raze reams

max assonance
mascon consonance
evermore narcosis

V.

axenic omissions
erosive oeuvres
non-moraic maneuvers

convex minisci
x-axis vs. z-axis
norm cones

numeric errors
excessive nexuses
sines – cosines

anxious recension
economic recession
seesaw incessance

insecure income
mammon commerce
marxism – communism

minimize avariceness
rove oversize casinos
commence inversion

successive concussions
rasa consciousness
eerie recurrences

rain in a vase
meniscus arc
run over

vi.

crass
sex
emissions

cum
semen
urine

menses
mucus
ova

woo
swoon
ooze

ass
arse
anus

eros
onan
amor

rim
screw
romance

inner
sinner
censor

acacia acariasis acarina acarine acarus accension accensor access accession accismus accra accrue accurse accuse ace acer aceraceae acerous acersecomic acervus aces acescence acinaceous acinar acinos acinus acme acne acomia acoraceae acorea acoria acorn acorus acosmism acouasm acousma acre acres acrimonious acris acroama acrocomia acromicria acromion acrosome across acu acumen acun aecium aeneas aeneous aeneus aeon aeonian aeonium aere aerie aerious aes aesc aesir aevi ai aim aimer air aircrewman aire airiness airman airs airscrew aise aix aizoaceae am ama amain amanous amanuensis amari amasesis amasius amass amaurosis amaze amazon amazona ame ameer ameiurus amen amerce america americaine american americana americanism americanize americium amia amice amici amicos amicus amie amine amino amis amiss amman ammine ammino ammonia ammoniac ammonium ammoniuria amnesia amnesic amnion amnis amor amorce amore amoroso amorous amorousness amour amrinone amsonia amur amusare amuse amussim an ana anacoenosis anacrisis anacrusis anacusic anaemia anamnesis ananas ananias anas anasa anasarca anasarcous ance ancien ancon ancora ancress anear anemia anemic anemone anesis aneuria anew ani anicon aniconic anima animam anime animi animis animism animo animos animus animé anion anionic anise anna annex annexe annexion anni annis anno annona annonaceae announce announcer annum annus anoa anoesis anomia anomic anomie anon anorexia anorexic anosmia anosmic anounce anoxemia anoxemic anoxia anoxic anser anserinae anserine answer answers anu anuran anuresis anurous anus anxious anxiousness ar ara araceae aramaic aramus aranea araneae araneous arare aras araucaria araucariaceae arawn arc arca arcane arcanna arcanum arceo arcus are area areas areca arena arenaceous arenaria arenarious arenose aria arianism arins ariomma arioso aris arisaema arisarum arise arius arizona arizonan arm arma armenia armenian armeria arminian arminianism arminius armis armoire armor armoracia armorer arms armure arnica arno arnoseris aroma arose arouse arras arrasene arrear arrears arrier arriere arriero arris arrive arrosion arrosive arrow arrows arrowworm arsenic arsenious arsine arson arum aruru as asana asarum ascariasis ascaris ascension ascesis ascian ascii ascoma ascus asia asian asimina asin asinine asinorum asinus asio asonia ass assai assam assama assassin asses assess assessor assize

assizer assizes assonance assuasive assume assur assurance assure asuncion asura asvins aswan au auc aum aura aurae aurar aurea aures auri auricomous auro aurora auroroa aurous aux auxesis auxin auxinic avaram avarice avaricious avarus ave avec avena avens avenue aver averni avernus averse averseness aversion aversive avi avian avicennia avicenniaceae avinosis avionic avionics avis aviso avo avoir avons avorum avow aware awareness awe awesome awn ax axenic axiom axis axon azo azoic azonic azores azure cacao cacicus cacus caeca caecum caesar caesarem caesarian caesious caesura caiman cain cairina cairn cairo caisson cam camaca caman camas camassia camaïeu came cameo camera cameraman cameriere cameroon cameroonian camino camorra can canas canaceous canavanine cancan cancer cancerous cancrine cancrizans cancun cane caneva canezou canine canis canna cannaceae cannae cannes cannon cannoneer cannons canoe canon canoness canonic canonize canons canorae canorous canvas canvass canvasser canzone car cara caracara caracas caranx carassius caravan caravanserai carcase carcass carcinoma care careen career careerism cares caress careworn carex cariama carica caricaceae caricous carina carioca carious carissa carman carmine carneous carnivora carnivore carnivorous carnosaur carnosaura carnose caro carom carouse carouser carre carrier carries carrion carrom carum carve carver casa casanova cascara case casein caseous casern caseworm casino cassava cassia cassimere cassino cassiri cassius casuarina casuarinaceae casuarius casus casuses casuss caucases caucasia caucasian caucus causa causas cause causerie causes cav cave caveman cavern cavernous cavesson cavia caviar caviare cavicorn caw cc ce ceasar cease cecum cen cenozoic censer censor censorious censoriousness censure censurer census ceraceous ceramic ceramics cercis cercus ceremonie ceremonies ceremonious ceremoniousness ceremoniuous ceres ceresin cereus ceric ceriman cerise cerium cermonie cerni cernuous cero cerous cerumen ceruminous ceruse cervicem cervicorn cervine cervix cervus cesarean cesious cesium cess cession ceux ciao cic cicer cicero cicerone ciceronian ciconia ciconine cieceronian cimarron cimex cimier cimmerian cinammon cinema cineraria cinerarium cinereous cineri cinerious cinnamomum circa circaea circassian circe circean circumcise circumcision circumincession circus cire cirrus cirsium cisco cismarine civic civics civis civism cnemis

vii.

amorous caresses
sensuous consensus
mucinous carnivores moan

exocrines
move
cerumen

a cinereous mourner
is an auricomous
mimic

a xenosaurus
in woven armour
survives in crevices

a scincus
conceives
in a cave

cane corsos
swarm
an azoic moor

a naïve rower
snoozes
in an ocean canoe

a nervous moon
rises over
a serene sea

viii.

cow nescience
ox survivance
craven ravens

arenaceous worms
swine viruses
zoonosis

ross river
murrain curse
ravenous ravines

invasive
rossicum
vines

rare arums
carcass aromas
enormous corms

nemexia
are
carrions

savour irises
crocuses
anemones

savour avens – rowans
rosaceous osmics
in consenescence

unsworn ransoms
warm unworns
wars unwon

unroven wire
unwoven armour
unsewn armwear

unsawn ramus
unseen scion
unrun race

unwise measures
unmown acres
uncommon concessions

essive non-uses
numerous misuses
vacuous causes

unsure reviewer
murcous masseur
omnivorous accruer

resume – résumé
sewers – sewers
sow – sow

rimose neverness
scorian wasness
iconic isness

X.

o.r. rosmarus
craves
ros marinus

rosmarinus
carries
aromas – memories

memories
reoccur
in cinema

cinema
zeroes in on
essences

essences
are
recursive

recursive
means
cocoa in a mirror

a mirror
is a canvas
as seen in meninas

even was i
ere
i saw névé

xi.

mannerism
over marrow
neurosis mine

zen exercises
usance nuisances
ms revisions

viennese
music
scores

amussis – examussim
armoire sureness
eames veneer

innocuous criss-crosses
incurious invariance
ruinous cave-ins

roman ruins
carrara corrosion
seven moai in a row

aniconism
no carven icons
no cave canem overseer

sosus meiosis
micromosaics so … oneiric
one cries

xii.

wee ones
receive
nice names

mia
irma
emmie

nico
cece
ewan

sara
aron
zoran

omar
marwa
amaira

oscar
ramona
noreen

ari
enzo
zosia

or annaeus
an arcane nomen
i.e. seneca

cocos cocus coerce coercion coercive coeur coevous coin coiner coins coinsurance coir coma comae come comer comes comic comica comma comme commence commerce commis commissar commission commissionaire commissioner commissure commix commixion common commoner commoners commonness commons commonsense commove commune communion communism comon comoros comose con concave concavo-convex conceive concern concession concessionaire concessive concesso concious conciousness concise conciseness concision concourse concresce concrew concur concurrence concussion cone conenose conic conima conium connaraceae connarus connivance connive connoisseur connu conover cons conscia conscience conscious consciousness conscire consenescence consensus conserve consomme consonance consuecere consuescere consume consumer consumere conure convenance convenances convene convener convenience conveniences conversazione converse conversion convex convexo-concave convince coo cor coracias coram core coriaceous corium corixa corm cormous corn cornaceae cornaro cornea corneous corner corners cornice corno cornu cornus corona coroner corozo corrosion corrosive corsair corse corsican corso corvee corvine corvus cos cosa coseismic cosine cosm cosmic cosmism cosmorama cosmos couci-couci coumarouna cour courier courroux course courseness courser courses cousin couveuse covariance cove coven cover covin covinous cow cower cowrie coxswain cozen coziness cr cracow cram crammer cran crane cranes cranium cras crasis crass crasse crassness crave craven cravenness craw crax craze craziness cream creaminess creance creancer crease cree cremains creme cremona crescive cresco cress crevasse crevasses creversion crevice crew crewman crex crier crim crime crimea crimen criminis criminousness crimson crin crinose crisis crisscross crius crme crocus croesus croiser croisis crone cronus croon crooner crore crosier cross cross-examiner crosse crossexamine crossness crosswise crow crown crows croze crucis cruise cruiser cruive crumenam crus cruse crux cruzeiro cucumis cue cui cuirass cuirassier cuisine cuisse cum cumin cuminum cunaxa cunner cunoniaceae cuon cur cura curaçao curassow curcuma cure curer curia curiae curiam curie curio curiosa curious curiousness curium curse curses cursive cursor cursorius curvaceousness curve

cuscus cusec cuss cuum cv cwm czar czarevna czarina ea ean ear earn earner ears ease easier easiness eau eaux eaves ecce ecco eccrine ecesis ecmnesia economic economics economize economizer ecrasez ecru ecumenic ecumenism eczema een eerie eeriness ein eira eirenicon eirenics eirenism eisen em emersion emerson emesis eminence emir emission emissum emmer emmew emo emu ename enamine enamor encaenia encomic encomium encore ene enema enim ennomic ennui enormous enormousness enosimania enosis enounce enow ens ensconce ensis ensnare ensue ensure enuresis envenom envious enviousness environ environs enviva enzone eoan eocene eon eonian eonism eons eos eosin eozoic er era eram erase eraser erasmian erasmus erasure ere erean eremic erica ericaceae erinaceous erinaceus eriosoma eris ermine ern eros erose erosion erosive erous err errare erroneous erroneousness error erroris eruca erwinia es esau escrow esox esse essen essence essive essoin esuriens eunoia eunomia eurasia eurasian evacuee evanascence evanesce evanescence evasion evasive eve even evenness ever evermore everness eversion evince ewe ewer ex examen examine examiner excercise excern excess excessive excise exciseman excision excrescence excresence excursion excursive excursus excuse exercise exercises exexacum eximious exmoor exocrine exorcise exorcism exsuccous exuviae icaco icarus iccusion ice iceman icon iconic iconism iconomania ie ies iiwi im imam imaum immanence immense immensum immerse immersion imminence immission immix immune immure imo imsonic in inane inani inanna inasmuc inca incanous incase incense incension incise incision incisive incisiveness incisor incivism income inconvenience increase incur incuriam incuriosi incurious incuriousness incurrence incursion incursive incus incuse inessive inimicorum inimicum inn inner innins innocence innocuous innoxious ins insane insanire insecure insecureness insincere insomnia insomniac insomnium insouciance insurance insure inure inurn invar invasion invasive inverse inversion invious invoice inweave io ion ionia ionian ionic iou iowa iowan ira irae iran irani iranian ire irena irenic irenicon iresine irian iris iroin iron ironic ironice ironism irons irreverence irrision is isaac isanemone isere isis isness isomer isomeric isomerism issue issuer issus isurus iv ivi ivorine ivresse iwis iwo ixia ixion ixora izanami ma maana mac macaire macao macarism macarize macaron macaroni macaronic macaroon macaw mace macies macon macoun macrame macro

xiii.

careworn
careworn
careworn

careworn
careworn
careworn

careworn
careworn
careworn

careworn
concerns
careworn

careworn
careworn
careworn

careworn
careworn
careworn

careworn
careworn
careworn

careworn
careworn
careworn

xiv.

son o man
sorrows on a cross
as orc arrows soar

a saviour in an
acanaceous crown
renounces sour wine

as sauran
or mairon
scans ennor

as saruman
or curumo
moves orc armies

as annas accuses
a conman
a sorcerer – a maia

númenórean nazarenes
messianic samwise
marian arwen

morian
mines are
ossuaries

a sam raimi movie
an mcu crossover
iron man cameo

sac memo
a saucer seen
in new mexico

cia crews swear
no serious mission
no cussac case

acamarians
minosians
iconians

aenar
reman
axanar

mars rovers
on once-overs
marineris cruises

arsia mons
anseris mons
ascraeus mons

non-answers
evasive maneuvers
zero-sum scenarios

avon communion cover
moon communion service
i am a vine – remain in me

xvi.

eros was
a roman amanuensis
ære ciere viros

issar-šumu-ereš
was a cosmos examiner
enūma anu omens

cranium wow
answers now:
name a szerző

anaïs nin
isaac asimov
mai-mai sze

marco vassi
marianne moore
rené maran

anne carson
una marson
césar moro

no case
in a canon – in an oeuvre
in viva voce rime

in vox maris
in sonics – in sermons
in maurizio nannucci neon

xvii.

si vis amari ama
renaissance reconnaissances
sir more was a new inn commie

muses amuse erasmus
suasoria convinces
marcus cicero

sinecure cosiness
exam acers
minerva reverers

crumenam reasoners
vico – new science
scienza nuova

arcane axioms
rerum caussas
sensus communis

common sense
norms – mores
nomos – manners

man-as-measure
is erroneous
me-ness

corsi e ricorsi
rise – acme – ruins
un cerc vicios

xviii.

anaximenes saw
ziemia as a coin
a macaron – an oreo

a narrow view seen
in six severian
sermons

occams razor
assumes ease – is a
sense-incision

waive civics
scorn reason
renounce nuance

cue a non-vaxxer
cue nwo masons
cue a mona sorriso

onion cures
insurance scams
census misuse

cressie
nessie
mussie

our universe
as one
massive ruse

macrocosm macrocosmic macromania macron macroscian macrozamia macrozoarces mai maim main maine mainer mainour mais maison mam mama mamma mammea mammer mammon mammonism mammose mamo mamzer man manama manannan mancunian mane manes maneuver maneuverer mania maniac manicism manicure manie maniere manis mann manna manner mannerism manners manor mans manse mansi mansion mansworn manu manumission manurance manure manus manx mao maoism maori mar mara maraco marasca marasmius marasmus marc marcor mare maremma mari maria marian marina marinara marine mariner marines marinism marmara marmarosis marmoream marocain maroon marrano marrow mars marumi marver marx mas masa masai mascara mascaron mascon maser maseru mason masonic mass massacre masse massein masses masseur massive mauers maui maure mauser mauvais mauvaise mauve mauvis maux mavis maw mawworm max maxi maxim maximis maxims maximum maxixe mazama mazarine maze mazer mc me mea meam mean meanie meanness means measure measures mecaenas mecca meconium mecum mein meiosis mem meme meminisse memo memoir memor memorem memoria memoriae memoriam memorize memorizer men menace mene meninx meniscium meniscus menomini mens menses menu menura menurae menziesia meow mer meracious mercenaria mercer merces merci mercies mercuric mercurius mercurous mere merino meriones merism merman mero mersion mesa meseems mesic mesmer mesmerism mesmerize mesne meson mesonic mesozoic mess messianic messianism messina mesua meum meus meuse mew mews mexican mexico mezereon mezereum mezzanine mezzo mi miami miasm miasma miasmic mica micaceous mice micmac micomicon micro micrococcaceae micrococcus microcosm microcosmic micromania micromeria micron micronesia microsome microsorium microwave microzoa micrurus mien mieux mim mime mimer mimesis mimic mimir mimium mimosa mimosaceae mimus min minacious mince mincer mine miner miners minerva mini miniaceous minim minima minimism minimize minimum minion minis minium minivan miniver minnow minnows minoan minor minore minos minus minx miocene miosis mir mire miri miro mirror mirrors mis misc misce misconceive miscreance miscue mise miser misere miserere miseri miseria miseris misers misname misnomer misocainea misoneism miss missa mission

missive missouri missourian missus misuse mix mixen mixer mizmaze
mizzen mnemon mnemonic mnemonics mnesic mniaceae mnium
mo moa moan mocassin moccosin moi moineau moirai moire moiré
mom momism mommon momus mon monacan monaco monario
monera moneran monism mono monoamine monocerous monoecious
monomania monomaniac monomer monomorium monoousian
monosemous monroe monrovia mons monsieur monsoon moo
moon moor moose mor mora moraceae moraceous moraine morass
morassic morceau more moreen moreover mores moresco mori moria
morion morisco mormo mormon mormonism morn morne moroccan
morocco morone moronic moroseness morosis morra morris morro
morrow morse morsure morus mosaic mosan moscow moses moss
mossa mourn mourner mourners mouse mouser mousse mousseux
move mover movere moves movie movies mow mown moxa mr mrs
ms mucin mucinous mucivorous mucor mucoraceae mucous mucrone
mucuna mucus muezzin mum mummer mums muon muonium
muori murcous murem murine murmerer murmur murmurous muros
murrain murre murrion murus mus musa musaceae musaeo musca
muscari muscas muscivora muse muses museum music musician
musics musomania muss mwera nacre nacreous naevose naevous
naevus naias naira nairne naissance naive nam name names nammu
nana nancere nanism nanna nanomia naomi naos narc narcissus
narcomania narcose narcosis nares naricorn naris narrow narrowness
narrows nasci nasicornous naso nason nassau nasser nasua nauran
nauru nauruan nausea nauseam nauseous navarino nave nazarewne
naze nazi nazism nc ne neanic near nearer nearness nec necessarian
necessarianism necessaries necio necromancer necromania necrosis
nee neem neer nem nemesis nemesism nemine neminem nemo
nemorous nene nenia neo neomenia neon neonomianism neorama
nereus nerium nerve nerves nervine nervos nervous nervousness
nervure nescience nescio ness nessun neurism neurosarcoma
neuroscience neurosis neve never nevermore neverness nevis nevus
new newari newcomer newness news newsroom newswoman nex
nexus ni niacin niais niaiserie nice nicene niceness nicosia niece
nieve nim nimis nimium nimonic nimravus nina nine ninon ninos
nios niramiai nirvana nis nisan nisi nisus niveous nivose nix nixie
nixon nizam no nocens nocuisse nocuous noema noesis noir noire
noise noises noisiness noisome nom nomia nomic nomina nomine

xix.

eniac
von neumann
enormous numeric sums

uranium arms
aim on aioi
on nurses

erasure
is a
war crime

evenness
means
massacres

u.s.a. vows
concussive rain
summons zeus

air zero
unesco ruins
casus causes

nas-nrc commissions
an increase in cancers
racism in science

no remorse
or succor – or sunrises
or mirror neurons

xx.

ozone woes
immense monsoons
scarce resources

excessive sunniness
nauseous miasmas
resinous messes

exxon crises
serious occasions
sea ice insouciance

a marine census:
coris wrasses – anemones
coors cans – one-use razors

various wares
waveson souvenirs
a microwave – a wii u

vesuvius simmers
seismic s-waves arrive
a seer warns us

mono no aware
sorrow in erosion
zen – zazen

aeneas rerum
an animaniacs rerun
a seminar in zaniness

xxi.

i am a mascaron
a varicose vein
a versiera

a sonic sierra
a necessarian crime
a neo-noir movie

i am as
corner averse
as a new mom

saran
on scissors
on saws – on axes

i am an excess
a macaronic mime
a mummer – a murmur

an unseen meme
a coverian nomos
a seussian zoo

an acerous moose
an anurous caiman
a sun sans coronas

an inimīcus mimic
a morse mnemonic
a woven wire sieve

xxii.

one summer
we saw an ex-marine
in a nissan minivan

run over a
woman
in reverse

we were sure
a serviceman
since we saw

on a rear now in ruins
an ominous maxim:
no winners in war

news crews were
soon on our corner
sirens in our ears

nirvana
on our
airwaves

we saw men convene
in an anxious swarm
saw cameras zoom in

on a rescue mission
or a crime scene
no one was sure

xxiii.

as soon as
someone is run over
carnivores are evermore curious

ravens accrue on rearview mirrors
crows caw ere
minivans swerve

as more cars amass
we are on our screens
in a reverie

we evince
no
care

some miseries
are a mere
cosmic inconvenience

our mom
is a run-on
swearer

mom murmurs
move move move
no one moves

crewmen arrive
assess our runner
our ex-marine

xxiv.

civvies
are
unaware

a newswoman
some seniors
some minors converse:

runner
reverse
rumours

seizure
swerve
serious

a no-nonsense woman
comes nearer our car
examines us – our insurance

we see some
crimson
viscera

we
revive
our screens

we
move on
vamoose

nominee nominis nomism non non-u nona nonconscious none nones noincrease noninvasive nonionic nonius nonoccurrence nonresonance nonsense nonsuccess nonum nonunion nonvenomous noon noose nor noria norm norma norman norn nos nosce nose nosiness nosism nosocomium nosomania noumenon noun nous nouveau nova novena novice novo novus now nowise nox noxious nu nuance nuances nucivorous nues nuisance numen numenism numenius numeric numero numerous numerousness numinous nummamorous nummi nun nunc nuncio nuncius nuova nurse nux nécessaire névé oar oars oarsman oarswoman oasis oaxaca oca ocarina occasio occasion occasionem occasioner occasions occur occurence occurrence occurrere occursion ocean oceania oceanic oceanus ocimum oenomania oer oeuvre oevum oinomania om oman omani omen ominia ominous omission omne omnem omnes omni omnia omniana omniousness omnis omniscience omnism omnium omnivore omnivorous on onanism once once-over one oneiric oneness onerous ones onine oniomania onion oniscus onomamania ononis onor ons onus oose ooze or ora oran orarian orarion orarium orc orcinus ore oreamnos oremus oreo orinoco orion orions orison orissa ormer ormosia oro orzo os oscan oscar oscine oscines oscinine osier osiris osmerus osmesis osmics osmium osmosis ossa ossein osseous ossia ossivorous ou oui ounce our ouranos ours ouzo ovarian ovarious oven ovenware over overanxious overawe overcome overcross overcrow overcurious overmeasure overrun oversea overseas overseer overserious overwise ovine ovis ovivorous ovo ovum ow owe own owner owns owr ox oxime oxonian oxreim ozone ozonium ra raccoon raccroc race raceme racer racerunner racine raciness racism rain rains raise raisin raison raisonne raisonneur ram rama ramazan ramie ramman rammer ramose ramous rams ramus rana ranarian ranarium rancor rancorous rani ranine ranivorous ransom rao rara rare raree rareness rari rarior rarissima raro ras rasa rase rasure raucous rave raven ravenna ravenous ravenousness raver ravine raw rawness raze razor razure razz razzia rc re ream reamer reams rear reason reasoner reasons reassurance reassure reaumur reave recce receive receiver recense recension recess recession recessive recision recommence reconnaissance reconversion recourse recover recur recure recurrence recursion recursive recurve recurvous recusance reeve rei rein reins reinsurance reis reise reissue rem remain remains remex reminiscence

remis remise remiss remission remissness remora remorse remove
remover remueur remus renaissance renew rennin reno renounce
renovare renown renverse reovirus reremouse rerum rerun rescission
rescue rescuer reseau reserve reserves reservoir resiance resin resinous
resonance resource resources resume reunion rev revenons revenue
revenues revere reverence reverie revers reverse reverses reversion
reversioner reversis revie review reviewer revise revision revisionism
revive revivessence reviviscence revoir revue rewa-rewa rez ri ria rice
ricin ricinus riem riemann riemannian rien rim rima rime rimer rimose
rimu rinse rire rise risen riser rissa risum risus rive riven river riviera
rivina ro roam roan roar roarer roc roccus rococo rocroi roe roi rois
rom roma romaic roman romana romance romancer romania romanian
romanism romanorum romanov romans romanus rome romeo romona
ron ronian room rooms roric rosa rosaceae rosaceous rosarian rosarium
rosas roscius rose roseaceous roseau roses rosicrucian rosicrucianism
rosin rosmarine rosmarinus ross rossini rou roue rounce rouse rouser
rousseau rousseauan roux roué rove rover rovescio row rowan rowen
rower rs rua ruana rue ruin ruinous ruinousness ruins rum rumanian
rumen rumex rummer rumor rumrunner run run-on rune runer runic
runner runnion runs rus ruscaceae ruscus ruse russe russia russian rv
réseau sa sac sacra sacrarium sacre sacris sacrum saimiri sais sam
samara samarium samarra same sameness samia samoa samoan
samovar sams samsara samson samurai sana sanaa sane sanies sano
sans sansa sansevieria saone sar sara saracen saran sarcasm sarcoma
sarcomere sarcosine sarcosome sarcous sari saron sarracenia
sarraceniaceae sarum sass sauce saucer sauciness sauna sauria
saurian saururaceae saururus saussurea sauve savanna savara savarin
save saver savior saviour savoir savor savoriness savour saw sawan sax
saxe saxicavous saxon sazerac sc scam scan scanner scansion scar
scarce scare scarecrow scarious scars scazon scenario scene scenes
scenic science sciences scincus scion scire scission scissor scissors
scissure sciurine sconce scone score scorer scores scoria scoriae
scorn scorse scorzonera scour scourer scours scow scram scream
screamer scree screen screw screws scrim scrimure scrivener scrow
scrum scum scurriour se sea seam seaman seance sear seas season
seawan sec secco secern secession secessionism secure secureness
secus see seem seems seen seer seesaw seine seines seisin seismic

XXV.

cenozoic mica
eocene newness
miocene muons

nimravus
anserimimus
seismosaurus

runic noisiness
errors – nonsense
nonce nouns

euouae
sarraceniaceae
zenzizenzizenzic

semes – sememes
recursive ai
neurons

essomenic mirrors
cancrine racecars
acersecomic vanners

excimer ions
xenon arcs
zirconia crowns

oven-warm
creamware in a
ceramic museum

xxvi.

annexes
eminences
excrescences

caron – macron
nosinė – coronis
anusvara – virama

an i soars
over an o
as in avionics

mine is
an exercise
in accismus

an
insecure
sinecure

crisis
aversion
a remix version

an ireneo
as in memorioso
never unconscious

as i was
so i am
no one cares

xxvii.

amazon.com
news.com
xxx.com

cnn.com
msn.com
xe.com

issuu.com
cisco.com
naver.com

asus.com
asos.com
unesco.ca

one.com
axs.com
simons.com

uwo.ca
uvic.ca
ouac.on.ca

rona.ca
avon.ca
mec.ca

m.me
wa.me
me.me

xxviii.

narcissism
concerns
me

sane maniac
main sane-iac
craziness eversion

career insomnia
immersion in
uneasiness

an awesome air
winnows recremenia
scoria cones overrun

raise no mizzens
no vanes
no sons

newcomers announce
a massive mirror
on mauna

an incursion
an invasion
a coercion

an
unveracious
aura

xxix.

carmen verse
wiccans – covens
minor arcana

manannán mac
a manx
sea-son

aos sí
merrows
sirens

nicor or
nix or
nixie

auras
curses
omens

orisons
swevens
visions

animas
enemas
exorcisms

ancrene wisse
severe ascesis
miserere mei

xxx.

even cranes
move en masse
in an uneven v

minnows
veer in
near-unison

cremains
commix
in an urn

we move
as one – our union
ever so amiss

our crimes
our innocence
our mess

our
nosism
our success

our rove-overs
our reminiscences
our remanences

our issues
our miscues
our excuses

seismosaurus seize seizure semen semi semic semicoma semiconscious seminar seminarian seminivorous seminoma semon seneca senecan senecio senesce senescence senior seniores senna senor senora sens sense senses sensorium sensuous sensuousness serac sere serein serene sereness serer seria seric sericeous seriema series serieux serine seriocomic serious seriousness seris sermon sermonize sermonizer sermons serous serow serranus serrurerie serum servare serve server service serviceman services servo ses sesame session sessions seven sever severance severe severs sevum sew sewer sex sexism sic sicarian siccaneous siccar siccus sicence siemens sienna sierra sieve sieze simazine simeon simian simious simmer simon simoniac simonianism simoom simoon simous sin sinai since sincere sine sinecure sinew sinews sinner sino sinornis sins sinuous siouan sioux sir sircar sire siren sirene sirenia sirenize sirens siriasis siris sirius sirocco sison sivan six size smear smeuse smew snare sneer sneeze snooze snore snow snowman so soar soave soccer socinian socinianism socioeconomic socius soi soiree soirie soma some someone somnia son sonance sonar sone sonic sonora sonorous sonorousness sons soon sooner sorcerer sorceress sore soreness sorosis sorrow sorrows sorus sour source sources sourness sous sousa souse souvenir sovenance sow sower sown suasion suasive suave success succession successive successiveness successor succinic succour succourer succus succuss succussion sucre sucrier sue sui suine suis suisse sum sumac sumer sumerian summa summarize summer summon summons sumo sun suni sunni sunniness sunrise suns sunscreen suo suos sur surcease sure sureness suriname surmise surname surnia sursum survene survivance survive survivor sus susurrous susurrus suum suva suzerain swainsona swami swan swansea swarm swasivious swazi swear swearer sweven swimmer swine swiss swive swoon sworn una unanimous unasinous unaware unawares unceremonious uncommon unconcern unconscious unconsciousness uncover uncrown une uneasiness uneven unicorn unicornic unio union unionism unisex unison unisonance unisonous universe univorous unix unman unmown unnerve uno unreeve unreserve uns unsavoriness unseen unsex unsinew unsown unsuccessive unsworn unveracious unwariness unwise unworn unwoven ur urania uranic uraniscus uranism uranium uranomania uranus urceus urea uremia uresis uria uric urine urman

urn urnam urosaurus urraca ursine ursinia ursus us usance use user
usine usnea usneaceae usurer usurious usus uvea uxor uxorious uzi
vaccaria vaccine vaccinia vaccinium vacive vacuous vacuum vae vain
vaincre vair vamoose van vana vancourier vancouver vane vanir vanner
vansire vara varan varanus varec varia variance varicose varicosis varimax
variorum various varium varix varna varsovienne varus vase vau vaurien
vavasour veer vees vein veins vena veneer venencia venenum venerance
venerer venerous veni veniam venice venir venire venireman venison
venom venomous venose venous venue venus vera veracious veracruz
verism vermian vermin verminous vermivorous vernicose vernier vernix
vero verona veronica verrazano verre verrons verruca verrucose versa
verse verses version verso versus verum verve vervecine vervis vesania
vesica vesicaria vesuvian vesuvius veuve vex via vias vicar vicarious
vice vicereine vicinism vicious viciousness vicissim vicuna vie vienna
viennese vies vieux view viewer views vim vimen viminaria vimineous vin
vina vinaceous vinca vincer vine vinea vinew vinic vino vinous viro virose
virum virus vis vis-a-vis vis-à-vis visa viscaceae viscera viscous viscum
vise vision visionic visive visna visne visor visum viva viva-voce vivace
vivacious vivamus vivarium vive vivere viverra viverrine vivers vivimus
vivre vixen viz vizier vizor voce voces vocis voice voices vomica voracious
voussoir vow vows vox wai wain wair waive wame wan wane wanion
wanze war ware wareroom wariness warison warm warn warren warrener
warrior warsaw was wase wasm wasserman wave waver waverer waves
waveson waw wax waxen wc we wean wear wearer weariness wearisome
wears weave weazen wee ween weimar weimaraner weir weismannism
weiss wem wen were werowance win wince wine winner winnow wins
winsome winze wire wires wireworm wirewove wis wisconsin wise
wiseacre wiser wive wivern wives wiz wizen woe woman womanizer
won wone woo wooer woon worm worms worn worricow worrier woven
wow wrasse wren wrox wu x-axis xeme xenicus xenium xenomania
xenomenia xenon xenosaurus xenurine xeransis xerasia xeres xeric
xerosis xerox xerxes xi xian xoanon z-axis zaire zairean zama zamacueca
zamarra zamia zamiaceae zanze zeme zemni zen zenana zeno zenzic
zenzizenzizenzic zeren zero zerronnen zeus zeze zimmermann zimocca
zinc zincic zinnia zion zionism zircon zirconic zirconium zizania zizz
zoarium zoea zoic zoism zona zonam zonarious zone zonure zoo
zoom zoomania zoon zoonic zoonosis zora zorino zouave zuni zuzim

xxxi.

we are on
cocaine
in vr

a xerox
circus in
a vizor

a cavernous
sensorium
in a narrow room

erosive environs
ensnare us
in a sucrose sewer

zanni
a nasicornous man
an acerose nose

rossa
a room-crosser
a cannoneer in a cannon

siouxsie sioux
an icon in
new wave music

momus unmoors us
no more are we in
our morass

xxxii.

aeromancers
amniomancers
auramancers

avimancers
axiomancers
canomancers

carromancers
causimancers
cineromancers

encromancers
iconomancers
mazomancers

moromancers
narcomancers
necromancers

oneiromancers
onomancers
oomancers

oromancers
ossomancers
uranomancers

uromancers
xenomancers
zoomancers

xxxiii.

a susurrous swarm
a verminous croon
manure connoisseurs

simians on vines
canaries in mines
one is suas – one is síos

mazama – mizmaze
nsa in our eaves
in our menus

mics – wires
moscovian
emissaries

mr. x
u.n. owen
nomen nescio

we are in a sim
a concensus view
neo is one

nixon was a sim
ur nana is a sim
ur niece is a sim

ur canine oscar – a sim
ur unwariness – same
even ur sims are sims

xxxiv.

envision:
no crave miniseries
no marc maron

no conveniences
no accessories
no vices

we are marie curie
uranium ore
in our arms

ceo missives
are our nemeses
vivimus vivamus

criminous secrecies
asinine service
onerous corvée

amicus meus
inimicus inimici
mei

i am remiss
oems seize me
immerse me – sirenize me

one more: anicca
one more: camaïeu
one more: imu im omw

XXXV.

an
asemic
omniana

nicecore movies
misworn swimwear
cornices in venice

casanova norms
eco-communes
river conservancies

erinaceus amurensis
monoecious maize
monoousian oneness

nicene sameness
insincere amens
anomoeanism

an omassum
is an inner
encomium

ennui
anomie
no more mr. nice

mass in c minor
minnie mouse
on ice

xxxvi.

an envoi on
aurora – eunoia
ouisea – omeros

on sonorous acousma
vroom vroom
wee-oo wee-oo

on niaiserie
on inaccuracies
on airiness

on ovoos – cairns
on acomia: some manes
are savannas

on croziers
on crescence
on monomorium minimum

now arrears are even
now concision is won
we crave variance – wean no more

so ceases our
minor excursus
in curvaceousness

six-x-six
oems
in a sase

Acknowledgements

Thanks to Geoffrey Morrison, for helping me smooth things out.

About the Author

Matthew Tomkinson is a writer, composer, and doctoral candidate in Theatre Studies at the University of British Columbia, where he researches sound within the Deaf, Disability, and Mad arts. Matthew is the author of *For a Long Time*, a chapbook out with Frog Hollow Press, and the coauthor of *Archaic Torso of Gumby*, an experimental short fiction collection out with Gordon Hill Press. His essays and shorter works have appeared in *Exacting Clam*, *The Town Crier*, *Theatre Research in Canada*, *Performance Matters*, *Sonic Scope*, and Anthem Press. He lives in Vancouver on the unceded territories of the xʷməθkwəy̓əm (Musqueam), Skwxwú7mesh (Squamish), and səl̓ílilw̓ətaʔɬ (Tsleil-Waututh) Nations.